T0132076

A Father's Dreams,
 A Daughter's Scenes

A Father's Dreams,
A Daughter's Scenes

Poems from a Father's Heart, Paintings from a Daughter's Hand

Jerry Botta & Julie Botta Fortunati

WestBow Press books may be ordered through booksellers or by contacting:

WestBow Press
A Division of Thomas Nelson & Zondervan
1663 Liberty Drive
Bloomington, IN 47403
www.westbowpress.com
1 (866) 928-1240

Scripture taken from the King James Version of the Bible.

ISBN: 978-1-9736-6726-1 (sc)
ISBN: 978-1-9736-6727-8 (e)

Library of Congress Control Number: 2019908567

Print information available on the last page.

WestBow Press rev. date: 8/13/2019

WESTBOW
PRESS®
A DIVISION OF THOMAS NELSON
& ZONDERVAN

Introduction
A Father's Dreams . . .
A Daughter's Scenes

Have you ever wondered what it would be like to paint a picture or to write a poem? Well, the book you're holding is a collection of poems from a father's heart and paintings from a daughter's hand.

Perhaps you've heard it said that, "the best people you meet are those you never look for". So it was with the coming together of this work; something totally unexpected, yet totally fulfilling.

In 1990, Jerry wrote his first poem during the Christmas season entitled, "A New Christmas Love". Without realizing it, a new tradition had begun: the writing of a new Christmas poem for the next 25 years until "Christmas Started That Way" was published. Almost simultaneously, everyday, true-to-life poems would also emerge along with growing encouragement for publication. He decided to do just that and to include a blending of his daughter's paintings.

At 19, Julie started her art career while attending Sonoma State University. At first, floral baskets then larger outdoor scenes. Subsequently, she continued her work in Florence, Italy under the guidance of both professional European and American artists until graduation. The variety of her subjects and use of colors not only became personally satisfying but sought after.

The desire for both father and daughter's works to be shared became increasingly evident as years would pass. Their feelings are that all the poems conveyed and paintings displayed will be especially enriching to you.

Contents

On His Terms ... In His Time

What is the dream . . . you wish to come true.
Something exciting . . . you feel you must do?

Is it a place . . . you've been longing to see;
Or is it the person . . . you've wanted to be?

Things didn't happen as once thought they would,
Now it's too late . . . to change if you could.

Relationships broken . . . hope ends in despair,
Will anyone listen . . . does anyone care?

God has a way to turn dreams around,
The answers you seek. . . . in Him can be found.

There are valleys to cross and mountains to climb,
But always on His terms. . . and always in His time.

May 1, 1992 - Florence, Italy

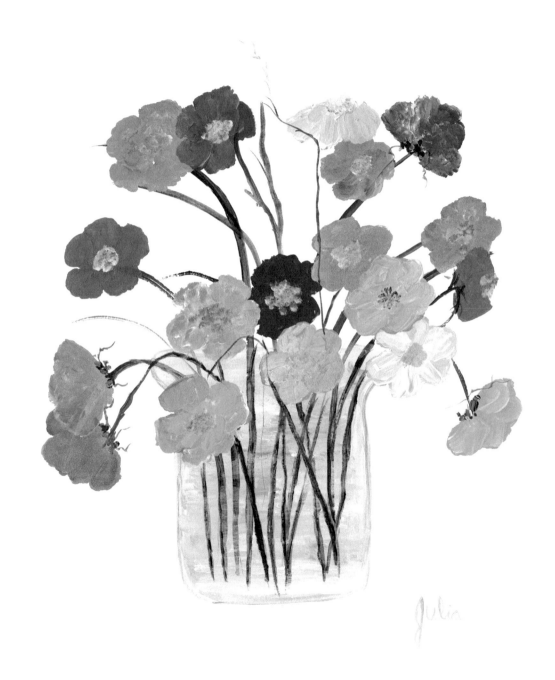

The Most Wonderful
Girl in the World

Twenty years ago today our baby girl was born,
 It was winter; cold and snowy that Colorado morn.
The waiting finally over, a daughter she turned out to be;
 What great excitement; what great joy; new parents then were we.

Watching her grow we knew at once, there was something about this child,
 Her ways were loving, sensitive; her spirit, meek and mild.

Through those early, formative years were all the things you'd like,
 Birthday parties, puppy dogs and once a brand new bike.

But beyond the fun and games of life, a choice she made one day;
 To serve the Lord with all her heart; to follow in His way.

We read the Bible stories of God's leading day by day,
 We showed her how to freely give; we taught her how to pray.

Then God's gifts began to flow for all of us to see,
 Her paintings filled our home with love; who knows yet what shall be.

So, now this precious lamb has grown; a young woman she became;
 "Youthful", she will always be ~

Julie is her name!

January 11, 1991

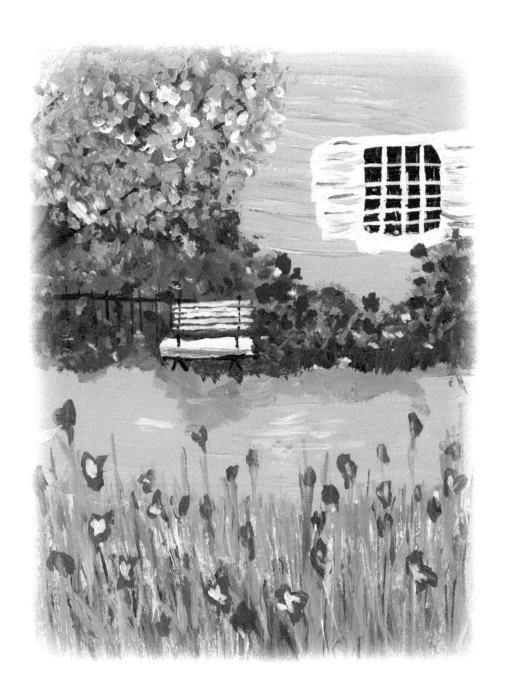

My Son, My Love

I wonder if you'll ever know how much I really love you,
I wonder if you ever know how much I really care;
One day that special time will come,
When you will know...and be well aware.

It's interesting how a life is shaped,
In so many different ways;
A job, a friend...an answered prayer,
By God...Who knows our days.

My son, my love...
You are to me the greatest son on earth;
Your very name means..."Given of God",
You have...eternal worth.

You're heart is very tender...your spirit, full of life;
You're always there to help a friend,
Make peace...
instead of strife.

Continue to put your trust in God,
The right direction...He'll point you toward;
You've heard me say it time and again;
Life works best...when you honor the Lord.

So, no matter where His paths may lead you,
Chosen paths by God above;
Jonathan, always remember...that you're the greatest,
You'll always be...my son, my love.

August 13, 1992

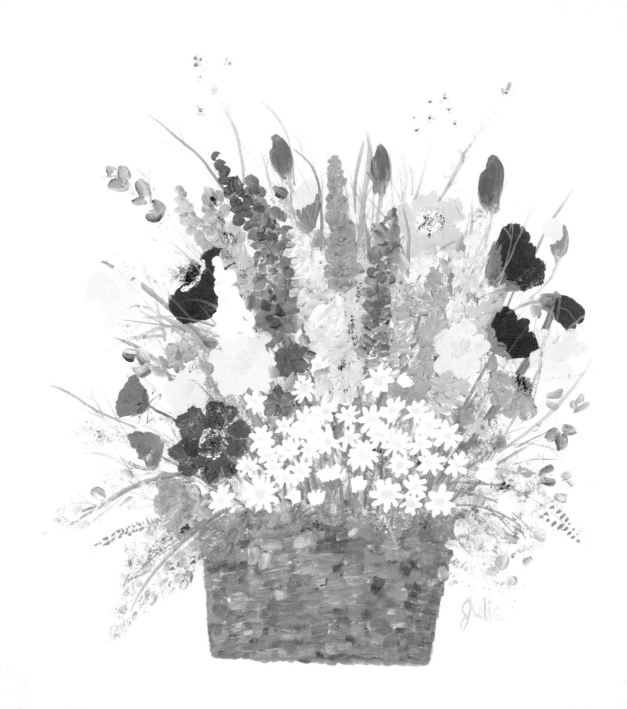

She shall be Greatly Praised

From the beginning she was there for me,
Without her...where would I be?

A good daughter she was for so many years,
Helping and serving...in laughter, in tears.

As a wife, mother and grandmother too,
She never complained of too much to do.

This woman of virtue...she can be found,
With values, compassion and love to abound.

Her life has been an example for all,
To honor the Lord...to answer His call.

So today, God's Word is rightfully raised,
"Charm may be deceptive and beauty doesn't last;
but a woman who honors God,
she...shall be greatly praised".

Mom...may all those who read these words
for generations to come...be as thankful
as we are to the Lord...for you.

Happy Birthday. I love you.

August 18, 1994/Eagle Rock, California

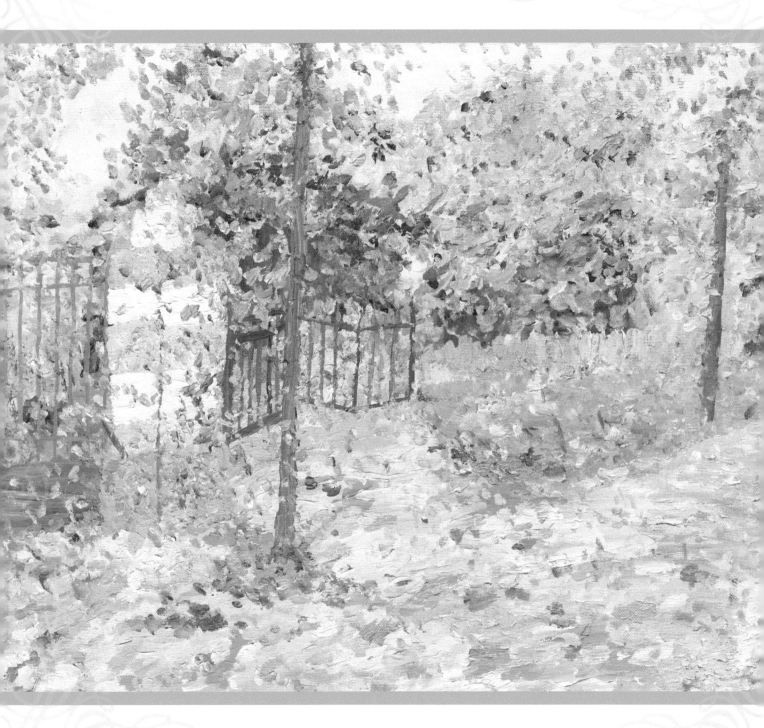

Happy Birthday, Dad!

Today, my father is seventy-five,
* Three quarters of a century and still much alive.*
But more than a quantity of years he has known,
* A quality of life to him has been shown.*

What can compare with a long, fulfilled life,
* Two loving children and a wonderful wife?*

Not without suffering, heartache and tears,
* Some disappointments through those many years.*

How often I'd turn to him for advice,
* In wisdom he'd speak ~ always gentle and nice.*
"Only the Lord", he would say, "can work these things out,
* Only the Lord, can bring it about".*

Yes, blessed of the Lord, my father is he,
* Overshadowed by God ~ rejoice all with me!*

I'll not worry for tomorrow; all things are at rest,
* My father is with me; near him, I am blessed.*

Happy Birthday, Dad. I love you.

January 1st, 1991

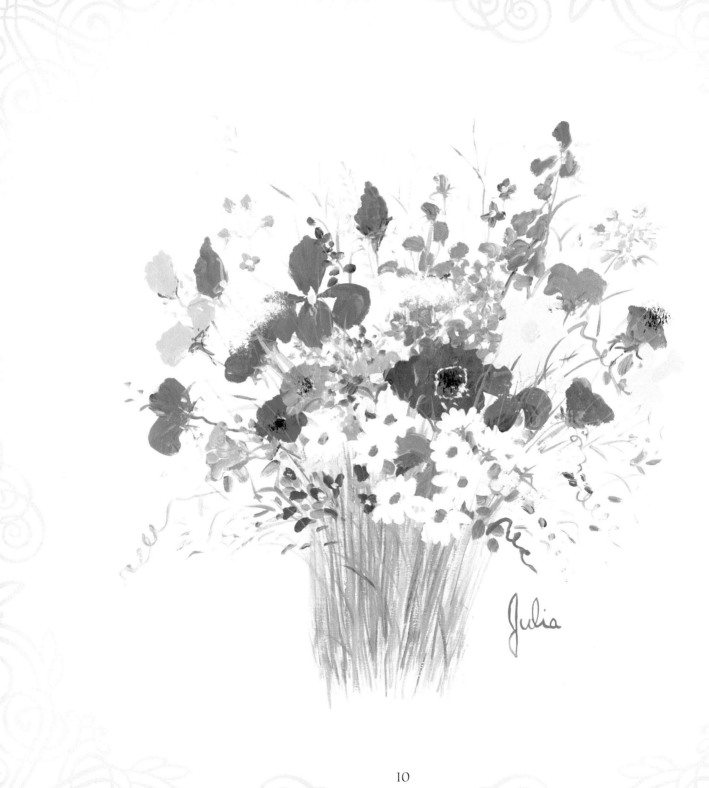

The Birds of the Air

Today a blackbird flew by with a mouthful of worms,
though her nest was hidden from sight;
She jumped through some thorns to get to her young,
then quickly returned into flight.

One minute later she was back with more food,
to nourish, protect and provide;
Again and again this scene would repeat,
a new family had come to reside.

Who would have guessed life had begun,
in a place you could hardly believe;
Couched in the thicket and thorns of a hedge,
God's creatures would give and receive.

It was then a whisper reminded my soul,
how God takes care of His own;

Why do I worry about my everyday needs,
is not my life before Him, fully known?

How often I'd search for answers,
from people who were empty of love;
Only disappointments would follow,
instead of trusting in Him from above.

But the feelings I have, the birds do not know,
fears of loneliness, sorrow and pain;
The tears that I've shed along the path of my life,
for what?...pride?...recognition?...or gain?

Lord, in this moment I turn unto You,
Your Spirit will help me to know;
Through the blood of Your cross and the gift of Your life,
I am clean ~ yes, whiter than snow.

So, grant me Your wisdom and grace from on high,
to function as one who would care;
Help me to love, release me to give,
make me free ~ like the

Birds of the Air!

April 7, 1991

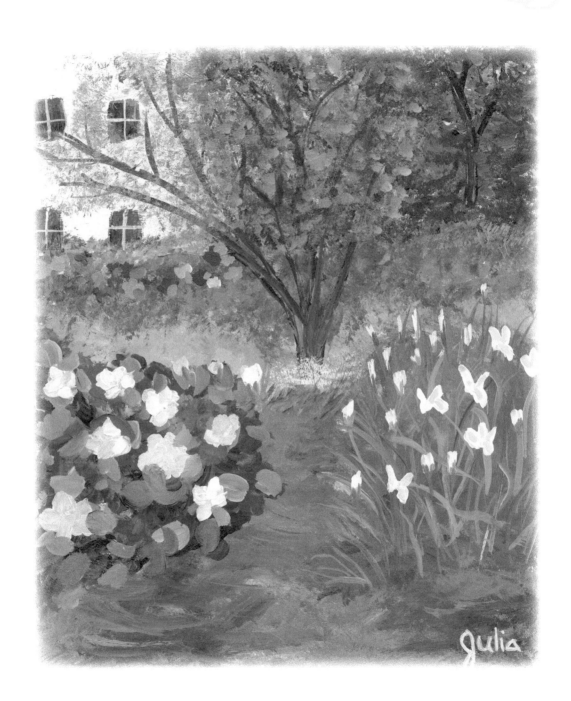

Broken to be Blessed

What do you want most out of life,
 Happiness, riches...freedom from strife?
Perhaps the fulfillment of childhood dreams.
 Most often, however, in vain...it all seems.

Decades are spent in the quest to succeed,
 Relentlessly working to meet every need;
Searching precisely to find the right niche,
 When in fact it's God's blessing that makes your life rich.

Do you function each day in the spirit of love,
 Forgiving...receiving His help from above?
He knows every motive, understands every deed,
 Those willing to serve...are chosen to lead.

So, are you willing...to be broken inside,
 Truly submitted, emptied of pride?
Then will you know complete peace and rest,
 Yielded to be used...broken to be blessed.

March 17, 1990

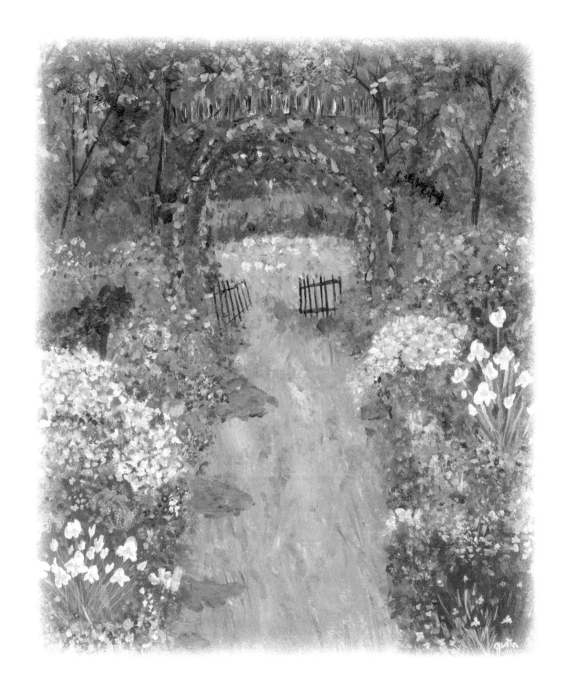

An Angel Unaware

Precious and beautiful...was this very short life,
Untouched by a world of sorrow and strife.

Innocent, tender, gentle and mild,
No time to grow...from baby to child.

How could this happen...how could this be,
When so content and smiling was she?

The gift that God gave...He took back in His arms,
Away from all dangers, fears and alarms.

In His presence...she always...will safely abide,
The answers, we'll know...when we cross to that side.

So, Lord...we are thankful for Your love and Your care,
And for the brief visit...of

An Angel Unaware

<u>Lauren Ashley Alexander</u>
August 9, 1991 ~ January 25, 1992

January 20, 1992

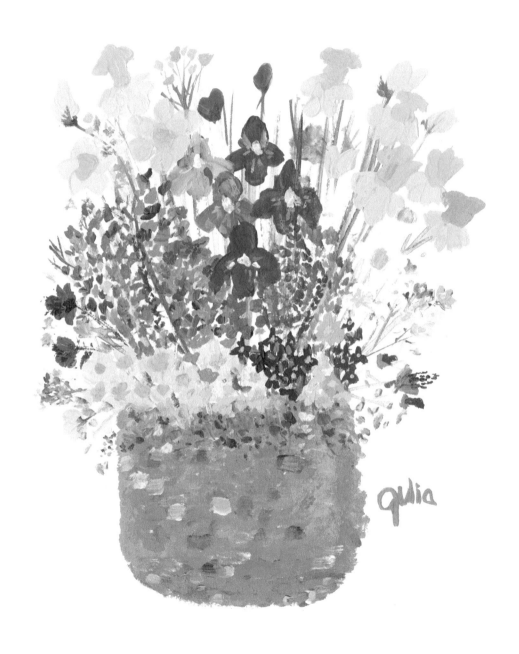

Water to Wine

Poured out like water, empty and dry,
 disappointed, disillusioned, no tears left to cry;
Promises broken, words empty, untrue,
 I'm poured out like water, Lord, what should I do?

There was a time I would fervently pray,
 pursuing Your will, walking Your way;
Then life became different, complex, so to say,
 ambition, position, seemed to pull me away.

Getting ahead, at hand was the task,
 but, ahead of what? ahead of who?, I would ask;
So, really, what does all of this mean?
 I need an answer, I'm out of steam.

Lord, do something new in my life this day,
 free me from anything, that would cause me to stray;
As Your child, I embrace all that is mine,
 because, Your miracle touch . . can turn water to wine!

June 20, 2016

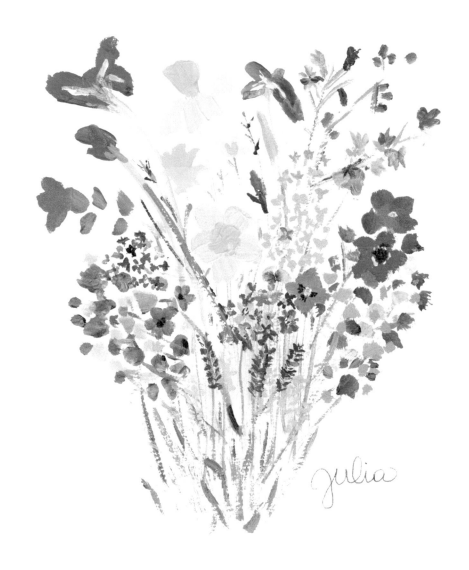

julia

A Guiding Hand

Sometimes the great people in our lives
 are not easily discerned;
Because we value more external things,
 we miss what we could have learned.

Friends are nice but they come and go,
 so often...they're just not around;
It's the family on whom you should rely,
 to them you're always bound.

Take my Uncle Albert,
 now there's an interesting guy;
Most people don't really know him,
 he's quiet, very witty...appears to some as shy.

Beyond his unique ability
 to make you laugh out loud,
It's just fun to be with him,
 alone...or in a crowd.

Growing up in those early days
 was hard but never sad;
Everyone helped each other,
 his folks gave all they had.

As years passed by many stories are told
 of those parents who prayed and cared;
A thread was woven through the fabric of life:
 love that lasts...is a love that's shared.

When war broke out the Army called him,
 he played trumpet as he led his band;
But seen in the midst of each crises hour,
 was God's almighty, guiding hand.

Yes, safely leading from above,
 the Lord was working His great plan;
Gently guiding...by His love,
 in His own way...to shape a man.

So, always trust what God is doing, and
 be extremely glad when you've found a pal,
Especially if, he comes even close...
 to being like my

Uncle Al.

June 8, 1991

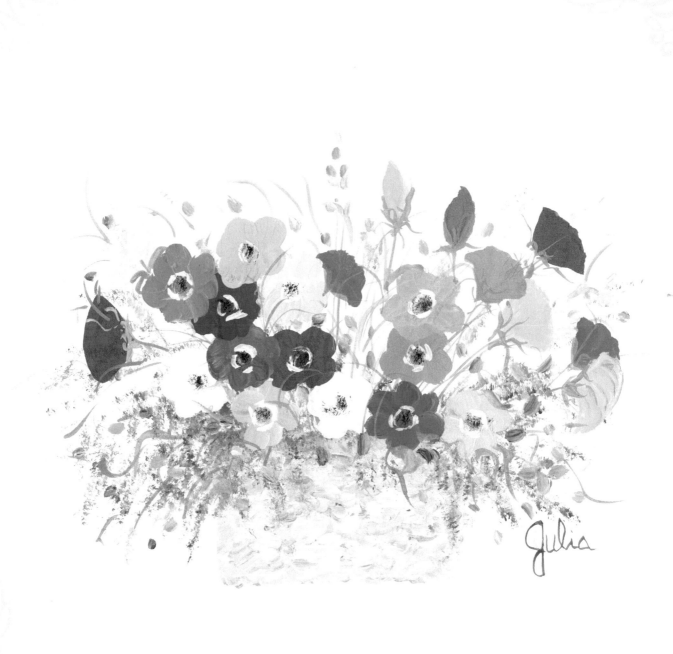

My Uncle Ben

What do you say of someone you love
 as you seek to honor his name?
Simply the truth...is more than enough,
 he wants no glory or fame.

Handsome, distinguished, gentle and kind,
 this man is held in esteem;
Husband, father, grand-father, friend,
 always...part of a team.

My hero in uniform decades ago
 I was only a boy of four;
Carefully, lifting me up in his arms,
 he just returned home...from the war.

Upon hearing reports of the Golden State
 he decided to move out west;
Santa Maria became his home,
 for him...it was life at its best.

Constantly striving day after day,
 he began...as a true pioneer;
Highest of honors he would later receive:
 his election...as Elk of the Year.

Supporting him always with unceasing prayer
 were his parents of long ago;
They believed in a son with hope in their hearts,
 they loved...more than any would know.

Yes, to me he's very special,
 in my eyes...a man among men;
I wouldn't trade him for the world,
 there's no one...like my

Uncle Ben

June 27, 1993

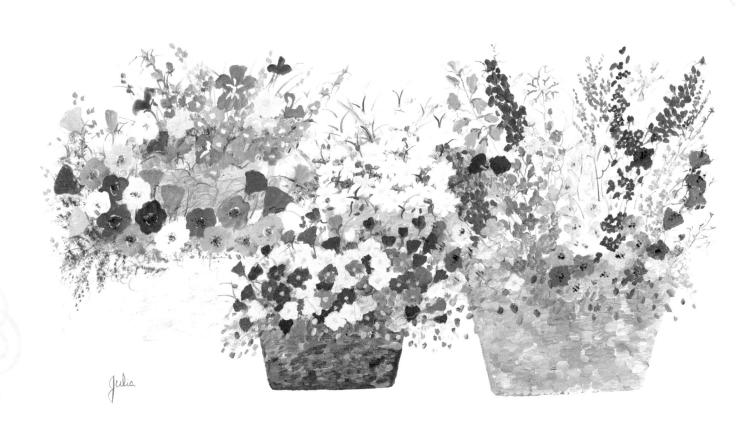

Julia

Henry DelMastro is His Name

Freeport, Farmingdale...Rapid City,
Minot, Kimball...Abilene;
My Uncle has lived in places,
Most of us...have never seen.

Firstborn son...now, great-grandfather.
Eighty years have come and gone;
His advice to those who'll listen:
"Don't turn back...keep movin' on".

Faithful, loving husband,
Aunt Helen, always...by his side,
Through fires, floods...some storms in life,
Love and laughter...never died.

A man of varied interests,
Music, science...planting seeds;
Yet, if you ask what's most important,
He'll answer: "not mere words...but deeds".

When all the family get together,
He'll drive south...come rain or shine;
At home, of course...his door is open,
First, a hug...then, food and wine.

So, Happy Birthday...to my dear Uncle,
He has always been the same;
Strong, consistent...man of honor,
Henry Del Mastro is his name!

With much Love
Jerry Botta April 19, 1996

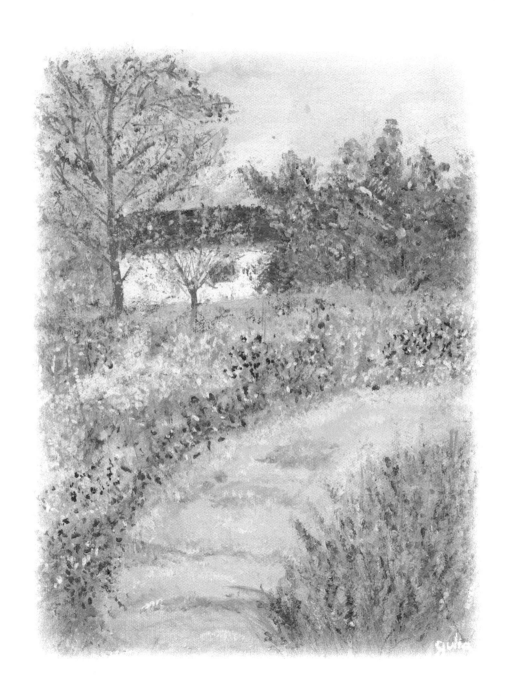

You're the Man, Uncle Dan!

Few have been so generous
* as Uncle Dan, you see;*
It seemed he gave to everyone,
* not only just to me.*

The time he took, the work involved,
* the price...he wouldn't care;*
Whenever help was needed,
* Uncle Dan was there.*

He loved his parents dearly,
* how much...we'll never know;*
In New York or California,
* with them always and on the go.*

Then, one day...a stroke, a challenge...
* Would it be more than he could bear?*
Drawing upon God's strength and courage,
* he came through...by love and prayer.*

Yes, love from friends and family,
* prayer...from many, once here now gone;*
Thank you Dan, for what you've taught us,
* keep looking up...keep moving on.*

So, from Mildred, Arthur, Helen...Albert,
* Ruthie, Margaret...the entire clan;*
From all of us who know and love you,

You're the Man, Uncle Dan!

October 24, 2001

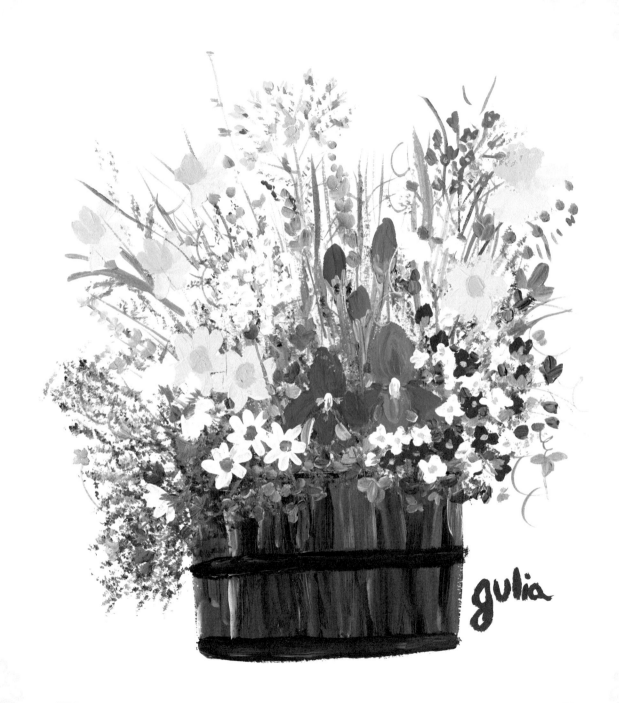

Graduation Day

We were all so happy,
A celebration was under way;
Music...cheering...laughter.
That.....graduation day.

In caps and gowns they entered,
It was Saturday...the 18th of May;
One by one each name was called,
On that.....graduation day.

Throughout lunch kind words were spoken,
Jonathan, of course, had much to say;
Later, we learned...his Grandpa died,
On that.....graduation day.

Our joy turned into mourning,
Sorrow, tears...had come to stay;
Who would have guessed all this could happen,
On that.....graduation day.

Then as a family we saw him,
Dad, our leader...so still he lay;
Unanswered questions began to taunt us,
Could there have been...another way?

His angel appeared again in splendor,
"It's time to go..they'll be okay;
Your name was called..your home is ready",
O grand and glorious

Graduation Day!

In loving memory of my father, Arthur Botta.
July 6, 1996

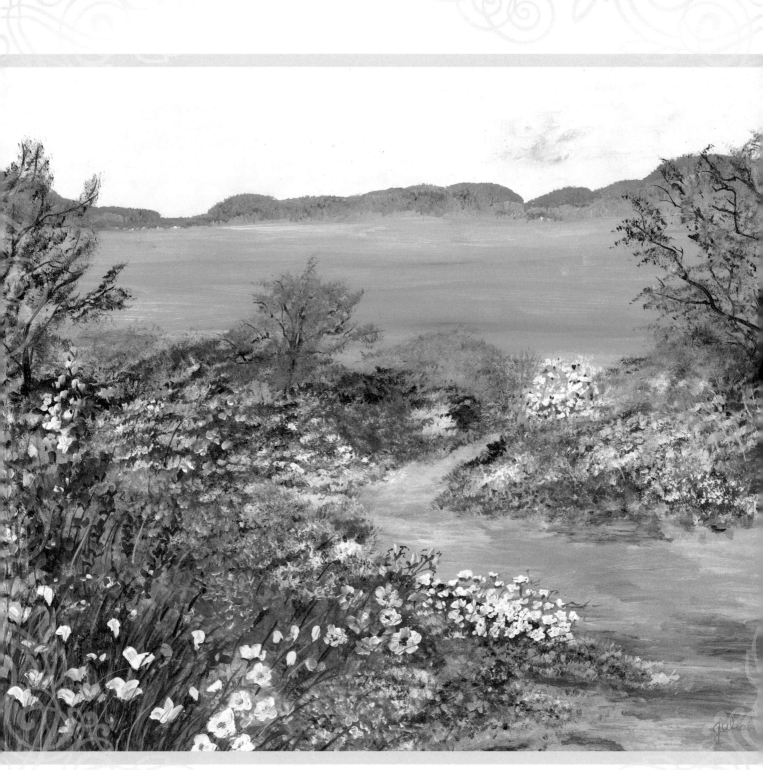

No Place To Hide

Each day the world is gripped by fear,
>Because of one man's pride;
Death and destruction enshroud the earth,
>Is there no place to hide?

Great nations at war are quick to display,
>Their strength, their arms, their might;
Who can withstand these hellish assaults,
>Who'll put an end to this fight?

Young men and young women join ranks in the field
>With weapons poised to attack;
Bravely, they put their lives on the line,
>Many will not come back.

Peace is fragile and elusive,
>Threats of terror rise from each side;
Unless Almighty God Himself intervenes,
>There will be no place to hide.

But the Lord sees the plight of His people,
>Every prayer uttered indeed He does hear;
Now is the time to call on His Name,
>Lift your voice unto Him without fear.

So, seek Him with your whole heart,
>Seek His presence and seek His face;
In so doing you'll discover
>That He alone is

Your Hiding Place.

February 10, 1991

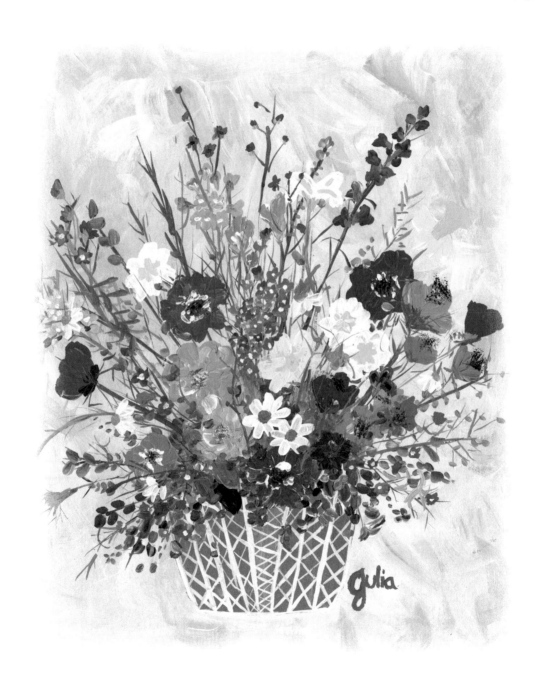

You Cannot Love Without Giving

Why are people unwilling to give,
 a moment...an effort...a dime?
Handwritten letters, personal calls,
 would be...infringements of time.

Some talk about giving...if they had more,
 motives and made of gold;
Yet, tightly closed hands become visible signs,
 of hearts...sadly grown cold.

Tenaciously clinging to things that won't last,
 many...will mourn and weep;
What is said throughout life is confirmed at the end:
 nothing you have...can you keep.

Pride is the issue...on the surface it seems,
 should surroundings be pleasant or rough;
But if you probe deeper; a root is exposed.:
 the fear...that there won't be enough.

To have freedom from fear...you must open to love,
 for love can dispel every fear;
The love of the Father - revealed through His Son,
 invites you to come...and draw near.

His forgiveness will bring acceptance and joy,
 restoration, peace...a new start;
Attitudes, values, priorities change,
 when His love...is renewed in your heart.

It's then you know the price He paid,
 to redeem...all who are lost;
The Good Shepherd willingly laid down His life;
 giving...is not without cost.

So, whenever you give...give out of love;
 to love...is the real joy of living;
Yes, you can give...without loving...but.

You cannot love...
without giving!

August 3, 1991.

31

There's Something About a Fire

There's something about a fire on a cold, wintry night,
 It speaks to your heart as it warms and gives light;
You begin to slow down, thinking back on your life,
 In front of that fire...there's no worry, no strife.

It's then you see how the years have gone by,
 The stresses alone...make you weary and sigh;
What have I done that really counts, I would say,
 Has my life made a difference, just a little, in any way?

Then softly the Lord would speak to my soul,
 Through His love and life...I'm being made whole;
But why don't I listen...to His voice...to His call,
 Am I afraid, He would ask of me...all?

"My presence", He says, "like the fire you're near,
 Will comfort and warm you...why do you fear?
You know in your heart My Word is true,
 I'll never leave nor forsake you...I'll see you through;
No matter how difficult or tough it may get,
 Your life is sustained...on The Rock it is set".

But then as I looked...only ashes I'd see,
 Is that what I am...burnt out, wasted...is that me?

"No, I was consumed so you could be free,
 I give beauty for ashes...the whole world will see;
My love and life in you...is really the key".

Yes, there's something about a fire on a cold, wintry night,
 It speaks to your heart as it warms and gives light;
When you least expect it...when you're home all alone,
 That's when God shows you...that you are His own.

January 21, 1998

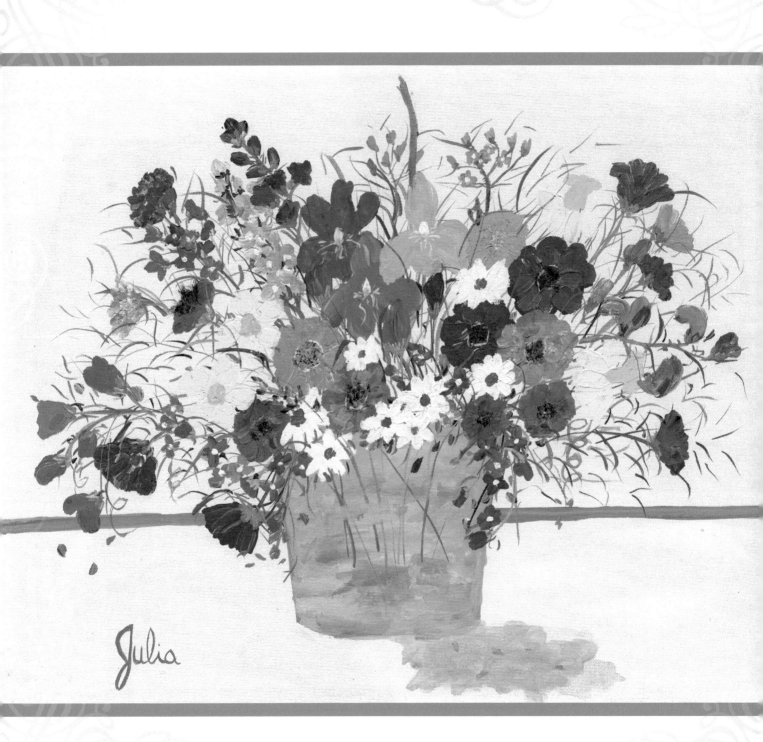

A Father's Prayer

In the home You've given me, O Lord, I'm content to know Your peace,
Your presence reassures my heart, my trials soon will cease.

Quiet, blessed quietness, from the noise and pace of life,
in the home You've given me O Lord, with my children and my wife.

In this house of many years now, changes don't happen fast,
new shutters, larger windows –– a new kitchen, but will it last?

The closeness of the family, a love that makes you cry,
these are to me most precious, things money cannot buy.

To sit down by the fire near my daughter and my son,
remembering how it used to be –– a time when we were one.

Then you see your life pass by, your dark hair turned to grey,
what will my tomorrows hold –– what's next along the way?

I trust in You, O Lord my God, all things are in Your hands,
how well You've taken care of us, at home, in distant lands.

I call upon Your name O Lord, to help me, day by day,
to lead those that You've given me, along Your path, Your way.

So, touch me by Your Spirit Lord, mold and shape me, just like clay,
let Your love and goodness fill me, touch me with Your hand I pray.

February 10, 1991

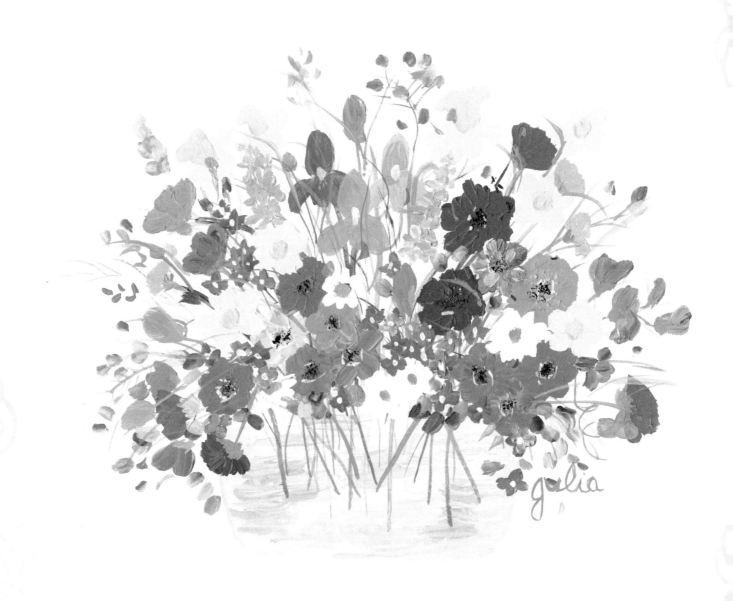

julia

He's Risen...He's Risen Indeed

Imagine the shock that first Easter day,
His tomb was found empty, the stone rolled away;
Few had believed the promise He gave,
that He would come back . . come back from the grave.

Rumors spread quickly, a scheme in the night,
deception, excuses repressing the light;
Yet, who could deny as He walked through the lands,
the wounds in His side, the prints in His hands.

He's still alive, the conquering King,
angelic choirs forever will sing;
All honor and praise unto Him Who did pay,
the price of redemption which opened the way.

So, are you among those rejecting Him still,
postponing decisions, resisting His will?
His power can free you, whatever you need,
for yes, He's risen...He's risen indeed!

About the Authors

Writing a poem or painting on canvas is an expression of one's heart. In "A Father's Dreams . . . A Daughter's Scenes", Jerry and Julie have done just that; through poems and paintings, expressed their deepest heartfelt feelings. As a Pastor in Colorado a half century ago, as well as many turns in the road since, Jerry's experiences and meaningful relationships are clearly revealed in his writings. A Midwest cowboy once told him, "it's not what you have that counts — it's what you do with what you have".

Once, while going through the difficulty of trying to retrace his steps from a trip in Italy years before, the poem "On His Terms, In His Time" came to fruition. The underlying message is that no matter how many changes or disappointments may take place, life always works best on God's terms and in God's time.

Along with his wife, Sara, of fifty-two years, Jerry continues to write poems. They have two married children, six grandchildren and reside in Southern California.

Julie has been painting for over twenty-five years and has studied under the guidance of both American and European professional artists. She has been very involved in leadership with "MOPS", Mothers of Preschoolers, along with study groups at Bible Fellowship Church in Ventura, California. She is married to Christopher Fortunati for twenty-four years and together are the proud parents of four children.

Printed in the United States
By Bookmasters